D1496246

# Artists'
# Instagrams

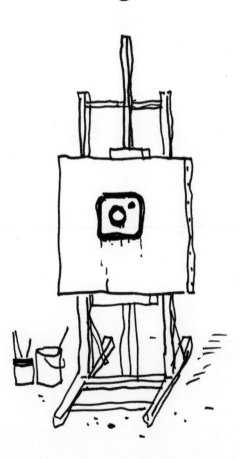

# Artists' Instagrams

## The never seen instagrams of the greatest artists

Jean-Philippe Delhomme

August Editions

We often think that the giants of twentieth-century art lived and worked in semi-isolation with limited groups of friends, so it's easy to forget that they, too, had Instagram accounts. Of course, they didn't have the massive following of today's it-girls and stars, but they had their own share of followers and likes, in well-adjusted proportions to the influence and pleasantness of their work. It is regrettable that to this day both art critics and historians have ignored this incomparable source of documentation, relying only on supposedly more noble artifacts such as letters, diaries, word-of-mouth rumors, ex-lovers accounts, and self-built legends. We do hope that these newly unearthed, never-before-seen Artists' Instagrams will bring a fresh object of study to a new generation of researchers, while the simple amateur will no doubt find interest in the direct access to the psyches of the last century's most prominent creators as well as further insights into classic art in the making.

Jean-Philippe Delhomme

 jack_pollock                    5 s

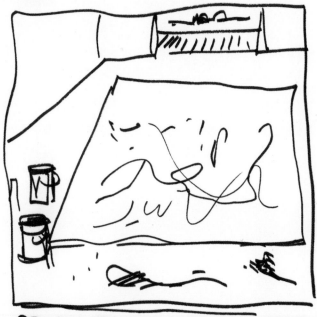

♡  ⬭  ↗                                    ○○○
♥ 3 likes
jack_pollock just started
ERIN.LEE  already gorgeous!

 rrose_selavy

...

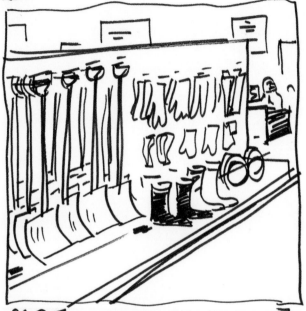

♡ ♡ ⊿

301 likes

rrose_selavy they are selling
unauthorized copies of my work!
cornell : shit!
view all 53 comments
8 Hours ago

 gauguin                    ...

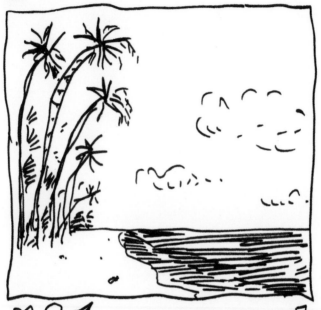

♡ ◯ ◁                                    ◻

liked by e_bernard, pontaven_mairie
and 37 others
gauguin  crowded beach
e.bernard is it a plastic bottle?
gauguin @e.bernard no,it's a
condom

mondrian_piet

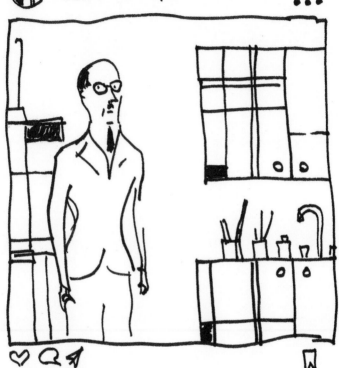

27 likes

mondrian_piet started painting my new #ikea kitchen today theovandoesburg Amazing!

@frida

...

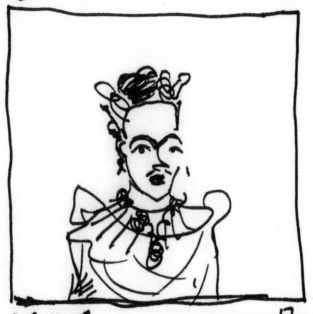

liked by d_rivera, trotsky and
1250 others
frida Good night
trotsky come to Russia
d_rivera my venimous flower ♥

 balthus

...

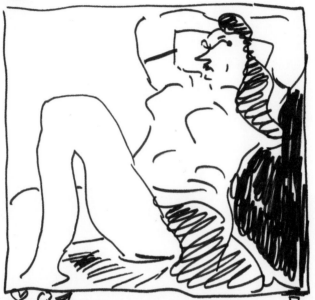

liked by oz, girodias and 3407 others
balthus my lawyer said I should
work with mature women
view all 699 comments

 braque le patron

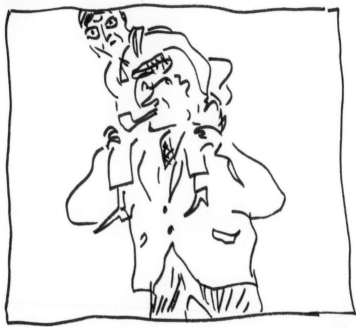

♥ 156 likes

braquelepatron @picasso on
my shoulders!
derain ah ah ah!
picasso @braquelepatron take
this off immediately!

**breton_andre**                    ● ● ●

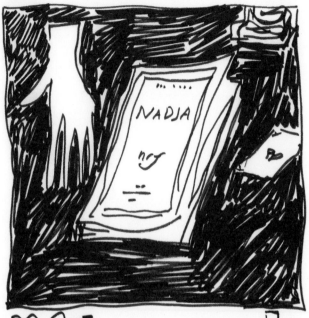

♥ 2507 likes
40 comments
breton_andré so excited
that my new book is out!
#nadja #andrebreton
@aragon congrats!
@nadja you're a small time
fucker

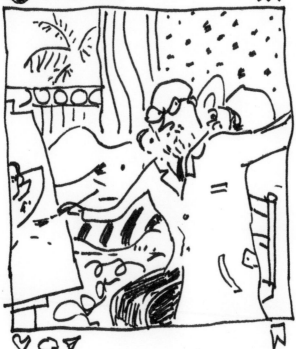

@h.matisse

♡ ♀ ▽

Liked by aragon, elsatriolet and
611 others
h.matisse At work #painting
#sieste #art #hude #window
#palmtree #interior #outdoors

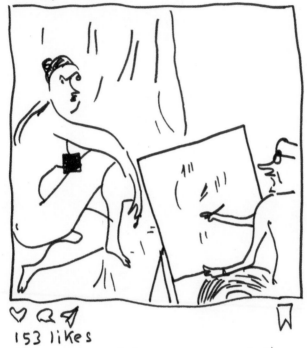

153 likes
Foireauxmodeles we've got the
best models for artists... more

 andy-warhol                    ...

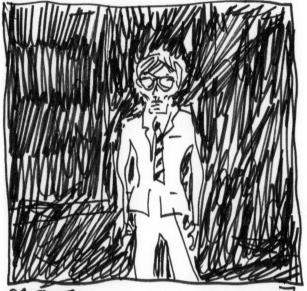

♡ ◯ ⊲                                    ⊓

liked by billyname, bob_colacello and
32 others
andy_warhol everybody will have
15K followers on Instagram
#superstars #15mnoffame
ultra.violet follow me ♡ ☺ ⚒

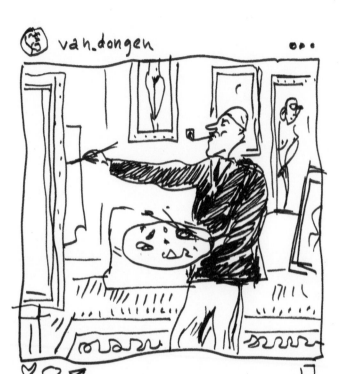

van.dongen ...

♡ ♀ ⏀                                        🏷

3213 likes
van.dongen thank you @revuedeparis
for the nice feature
view all 130 comments

jack_pollock

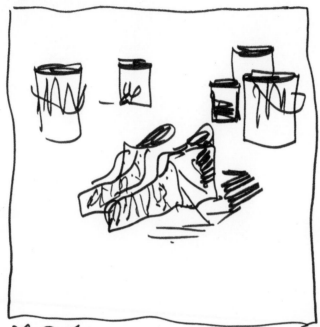

106 likes

jack_pollock why the hell is Hans insisting on me putting on my old shoes? Are they more interesting than my painting?

view all 6 comments

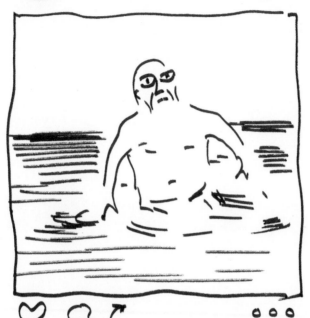

picasso    2h

♥ ⚲ ↗                    ◦◦◦

♥ 4789

view all 196 comments

picasso back to my favorite playa #summer #beachbum #pampelune #paintersin water

Duncan you rock

NOAILLES come by for a drink

mita728 you're the best

 louisebourgeois ...

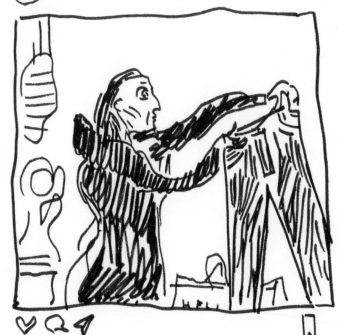

751 likes
louise bourgeois helmut sent
a nice pair of jeans
helmut private ♥

 a_giacometti                1w

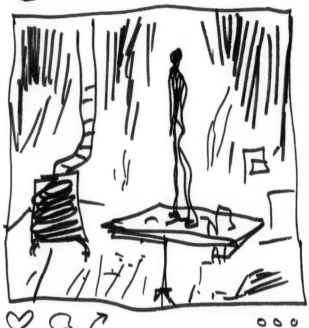

♡  💬  ↗                              ○ ○ ○

♥  17 likes
a_giacometti Missed the mark,
as always!
rolandd give it to me if you
want to destroy it
damedecoeur gorgeous!...don't
destroy it!

gauguin    •••

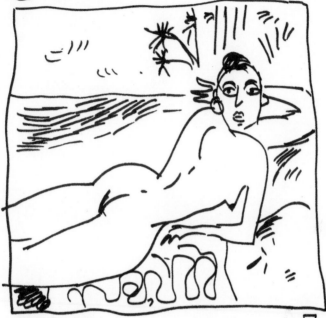

liked by e. bernard and 21 others
gauguin tae-ko popo mae kaopee
koulou koulou teha-amanaha
see translation

beuys

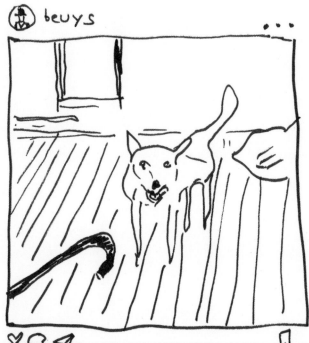

281 likes

beuys just found out the coyote
has his own instagram account!
coyote yep!

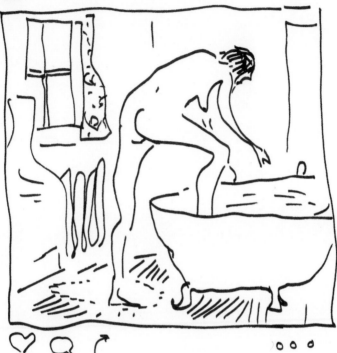

pierre.bonnard   Marthe trying out
our new bath tub   #bathtub
 #nude  #southoffrance

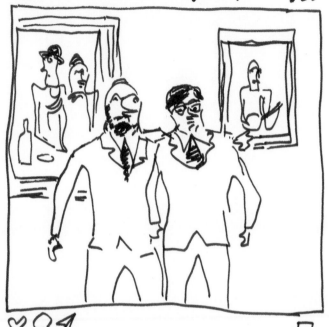

@ ambroise_vollard_gallery

...

412 likes

ambroise_vollard_gallery @picasso opening
last night
fernande love his work
picasso thank you @ambroise_vollard_gallery

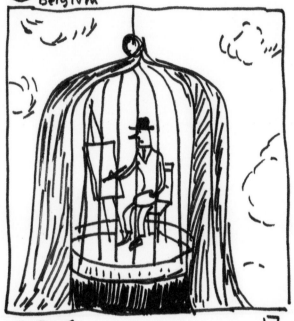

♡ Q ◁                                          ⊓

liked by max_ernst and 63 others
magritte  social media  #art
 # surrealism #belgium
teriade how is my cover coming
along?

@ louisebourgeois                    ...

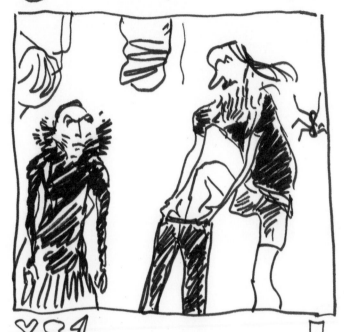

827 likes
louisebourgeois helmut's jeans
are too tight for Jerry!
helmutprivate my assistant is
sending a larger size right now
helmutprivate does Jerry know
his size?

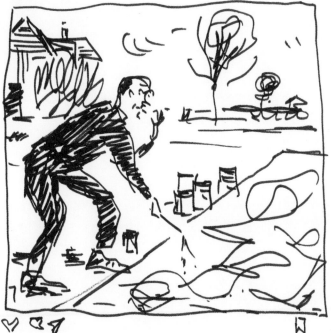

130 likes

jack_pollock I'm not your fucking actor!

cedartavern ♥♥♥

Bohemianpainter Tell them to go fuck off!

manwithacamera can I hire you for my next film?

 beuys

...

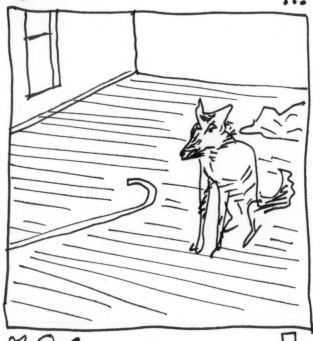

328 likes

beuys coyote says I'm posting too much

♡ ▢ ◁                                    ⊓

4718 likes
van_dongen selfie as Neptune
# selfportrait #neptune #selfie
#instagood #art
gauguin 🐬🐬🐬
view all 234 comments

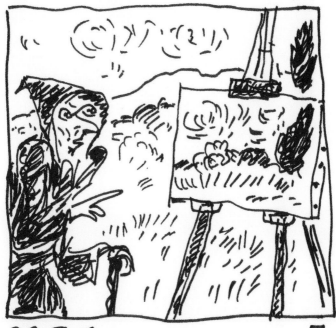

@van_gogh

...

♡ ♡ ◁ ⟋

13 likes

van_gogh old crazy woman said
my painting will become a
hand bag and people will make
tons of money with it.
gauguin Ha ha ha

 rrose_selavy

♡ ♡ Q ⌀ ⊿                                                    ⊓
50 likes
rrose_selavy monday mood
ttzara would you sign mine?
view all 13 comments
20 minutes ago

 buffet

...

♡ ♀ ⤴      ⎘

liked by annabelle, p_berge and 732 others
buffet Met this clown today who looked
just like my paintings #clowns
annabelle ♥♥♥
m_garnier stunning

 h.matisse ...

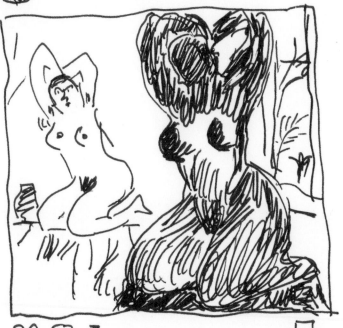

458 likes

h.matisse pierre says Americans
won't buy it if the nipples are
too obvious

mado-1 such a pity

josemax F...'em!

coolgirl 2787 😠 🙁 😣 so sad

6hrs ago

⊘coyote  •••

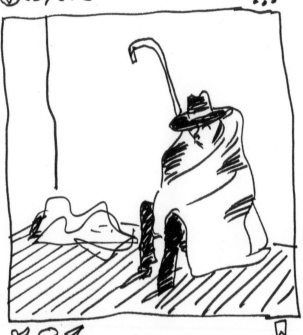

17 likes

coyote what's wrong with
instagram ready art? #art
#artworld #contemporaryart
#performance #beuys

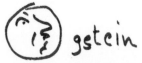 gstein

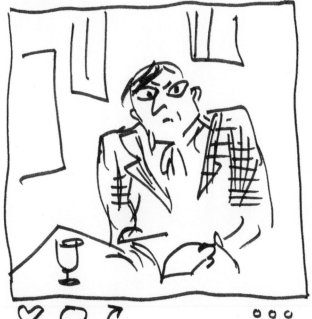

201 likes

gstein : I think Picasso is
        Jealous of my book

ELSAL : I want to meet you

alicetoklas : you're the best

@a_giacometti                    16h

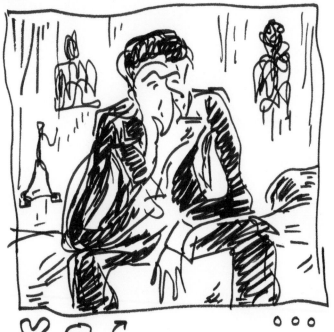

♡ ⭕ ↗                           o o o

♥ 23 likes
a_giacometti I failed all the way
KUMCAT love your work
J.genet what's the best way to
contact you?
YOSHII 79 please look at my
work

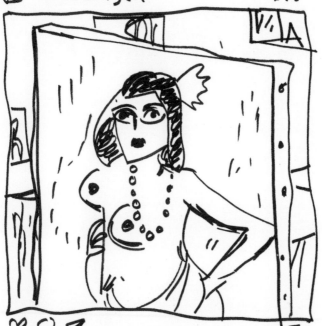

○ van_dongen     ● ● ●

♡ ⊂⟩ ⊿        ⊓

Liked by vlaminck and 213 others

van_dongen in progress

Liselotte213 love your work better than matisse

van_dongen @liselotte213 thank you

h.matisse stop copying me

 p. manzoni

...

Liked by ozpurple, KarmaKarmag and
1059 others
p. manzoni new shit
erika so good
jessart in love
germanocelant 👍

louisebourgeois

•••

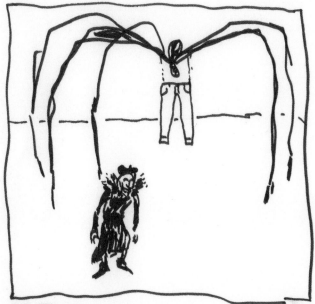

2702 likes
louisebourgeois in the mood for laughs
helmutprivate 😄
view all 237 comments

 Fernand_léger

. . .

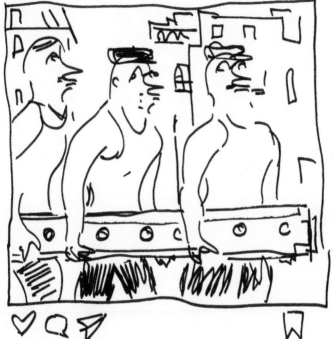

419 likes

Fernand_léger Inspiration
romain Stunning
Jeanne_b

**a_giacometti** 2 d

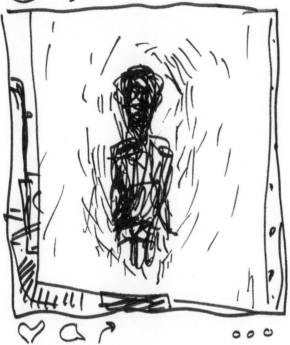

♡ 🗨 ↱                    ○ ○ ○

23 likes
a_giacometti will erase
and start all over again
DJEF: look at my work edjef
Marijo: c'est joli

 andy_warhol

...

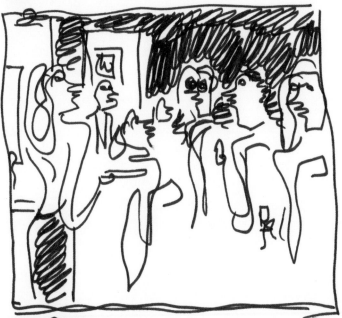

♡ ⬭ ✈

Liked by billyname, g-malanga and
237 others
andy_warhol stayed 5mn at Diane's
birthday and left with Glenn

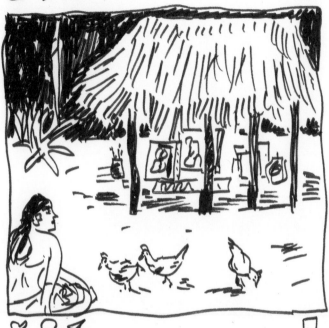

## gauguin  ...

♡ ⬡ ◁                                    ⬛

7 likes

gauguin I'm subletting my studio for
2 months, link in bio

annah_lajavanaïse you creep 🖕

brooklinpainter is there AC?

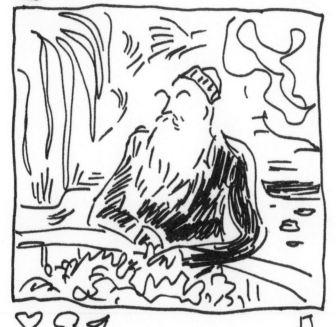

## monet

...

264 likes

monet Thank you @nadar for the nice shot!

maupassant you look like a fucking hipster on this!

 p.manzoni

•••

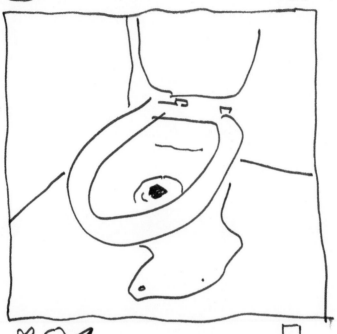

♡ ◯ ◁

liked by germanocelanti, hansulricho
brist and wimdelvoye and 2758 others
p. manzoni  hard work
wimdelvoye  you rule
francescamilano  hilarious

 **ambroise_vollard_gallery** . . .

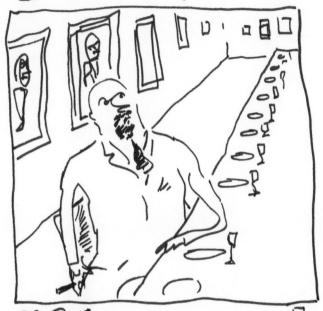

♡ ⍥ ✈ 🔖

liked by **picasso, cezanne_paul** and 840 others

**ambroise_vollard_gallery** thank you art basel Hong kong for the nice dinner Derain wish I was there

**pierre.bonnard**

♥ Q ↗                                      ○ ○ ○

♥ 23

pierre.bonnard Beau temps
vuillard when are you back
in Paris
badhairday this is awsome

van_dongen

...

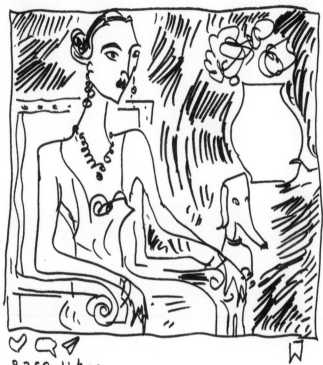

2358 likes

van_dongen commission

thesphinx Gorgeous ♡♡♡

eve_france love this! ⚱

thesocietypainter I could do this for less
money

view all 37 comments

a_giacometti                    • • •

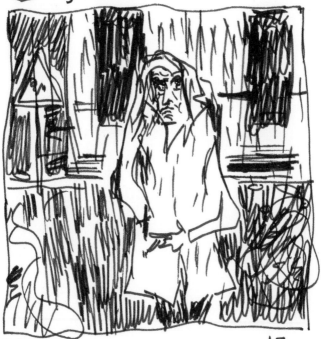

♡ ⬤ ⏩                              🔖

liked by annettearm, jeangenet
and 180 others
a_giacometti thank you @cartierbresson
for the great picture: I look even
more sad than usual

⊛ gauguin                                    ···

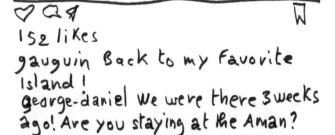

♡ ♀ ⊿                                          🔖

152 likes

gauguin Back to my favorite
Island!
george-daniel We were there 3 weeks
ago! Are you staying at the Aman?

breton_andre     . . .

♥ ♡ ◎ ➤

♥ 1000 likes

breton_andre @madame_sacco says
that my chattels will be exhibited
in a major cultural institution.
But this will happen after my
death.

pauline287 Too bad

pierreduchateau Genius

 picasso · · ·

♡ ♀ ⫽                                                    ⊔

3857 likes

picasso excited by my new
collab with a car
manufacturer

view all 146 comments

malevich

32 likes
malevich White on white
#noFilter #suprematism
popova 👍👍👍
KatarzynaKobro 🙏

picasso

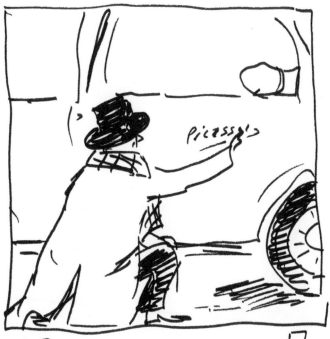

5848 likes
PICASSO signing cars today!
Jacqueline so good
Teriade is it a limited edition?
4 MINUTES AGO

shortterms_atelier
sponsored

• • •

♡ ⊙ ◁

12 likes

shortterms_atelier stunning
Montmartre genuine artist
studio short terms rentals...move

 rothKo1000                    2h

♡ ▢ ↗                                    ○ ○ ○

♥ 360 likes
rothKo1000 And another one
pepi woh!
iris ² so beautiful
chrispainter nice one M. Rothko

louise bourgeois
JFK airport

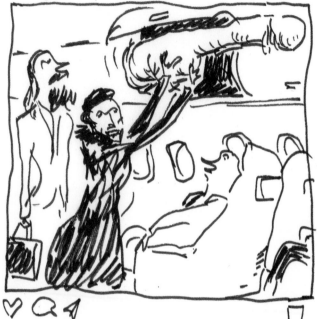

3024 likes
louisebourgeois Jerry said we
don't have to check it in
view all 159 comments

minotauremag

...

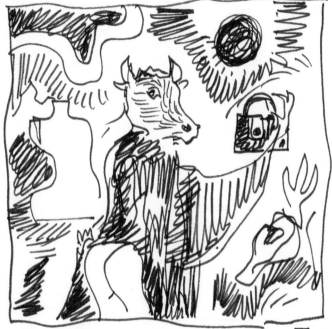

liked by h.matisse, derain, g.bataille
and 634 others
minotauremag our fashion issue
is out #Fashion #Surrealist #art
#handbags #luxe #jewelry

 albert_marquet

• • •

♡ ⬭ ⟶                                    🔖

37 likes

albert_marquet worried about
global warming...will there
be snow again?

3 days ago

 buFFet

• • •

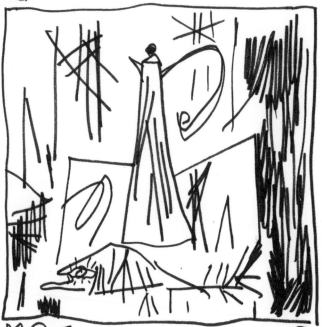

♡ ♡ ⊲

liked by annabelle, m_garnier and
1026 others
buFFet mood of the day #painting
#oilpainting #clowns
m_garnier 🎨 already sold!
cancale marée love!
le barrista ☕☕☕

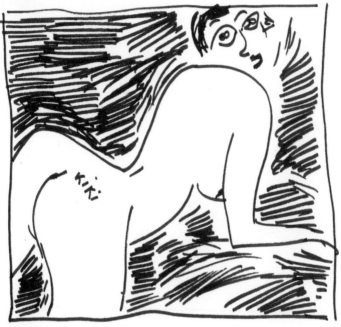

man_ray        3h

♡ ⟳ ↗          ∘ ∘ ∘

2758 likes

man_ray shooting @kikidem
for @minotaure
juice7 @ missmini
synthetik I wanna meet u

 a_giacometti                    • • •

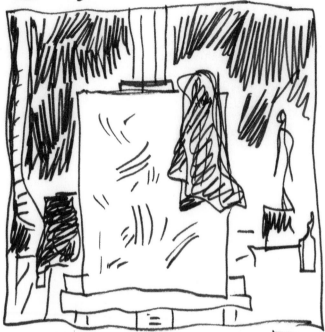

liked by jean-genet, annettearm
and 213 others
a_giacometti I wiped it all out, 2am.
Isaku.yanaihara ♥

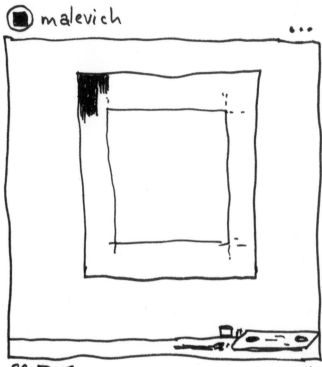

I like
malevich in progress
KatarzynaKobro already great

 edhopper                    8h

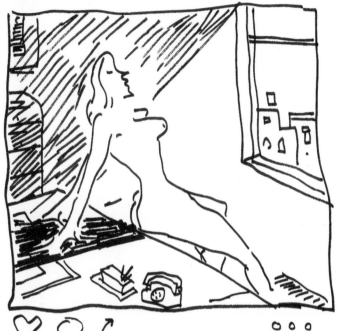

♡  ◯  ↗                              ○ ○ ○

♥  519 likes

edhopper Sunday at the
office #newwork #Sunday
R.Carver Do you do book covers?
sarahD this is so gorgeous
philosophymag stunning

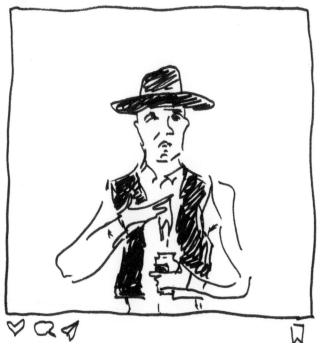

(○) beuys

♡ Q ⊲                                    ☐

1012 likes
beuys Honey tasting. Thank you
@lamaisondumiel !
lamaisondumiel 😋 😋 😋 ⛵

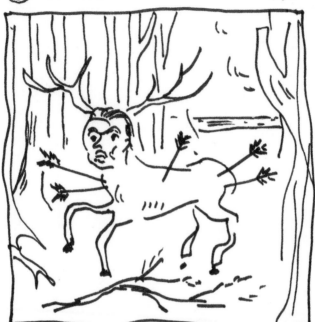

Frida

liked by trotsky and 941 others

Frida Wounded Diego, oil on canvas

dali

view all 152 comments

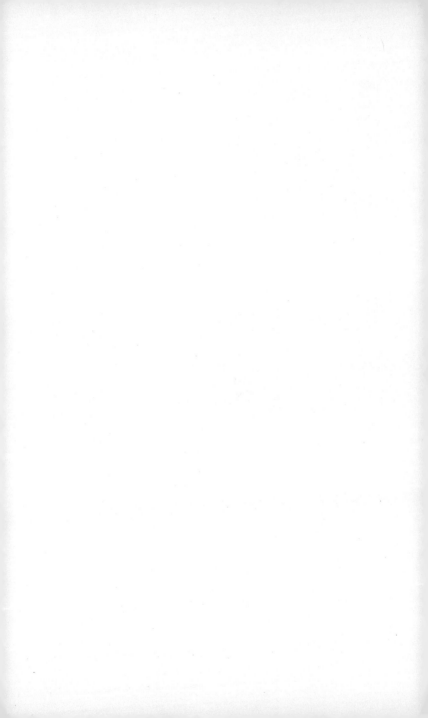

@h.matisse        ...

12 likes
h.matisse having some
fun with paper today
petitesmains you are so
inspiring! ♡♡♡
4mn ago

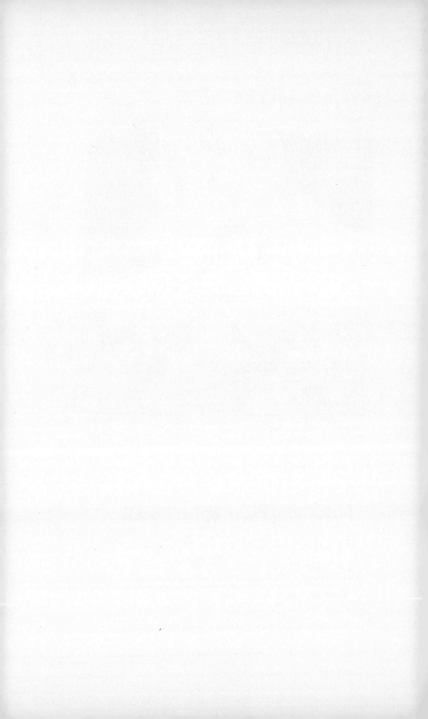

gstein

188 likes

**gstein** A rose is a rose is a rose #creativewriting #poetry #rose #flowers

**petitedame** So beautiful

**andrewl** Do you teach?

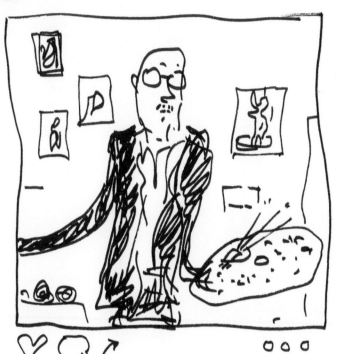

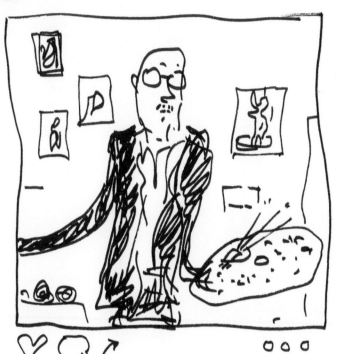

♡ ⬚ ↗                    ○ ○ ○

🖤 64
pierre.bonnard  mood of the
day # selfie
odile from nice  love this
man about style  🖤 🖤 🖤
paulhan  love your jacket

# h.matisse

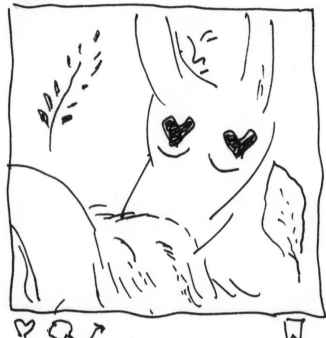

503 likes

h.matisse 31 celsius in Nice today #hot #nice #nude

elsa ♥♥♥ Gorgeous!

dali free the nipples!

picasso we'll email you contact of our air con man 👃👃👃

 rrose_selavy                    ...

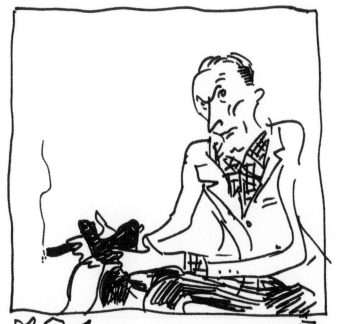

♡ ◯ ↗                                    ⊐

liked by picabia and 562 others
rrose_selavy videogames are
so much more fun than chess
picabia Did you try FIFA?
rrose_selavy @picabia Grand
Theft Auto!

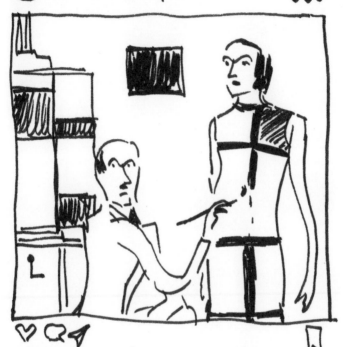

⊕ mondrian_piet

♡ ❍ ⌂ ◁

liked by nelly and 16 others

mondrian_piet when you don't have money to buy expensive clothes for your lady, you have to come up with ideas.

 vuillard

...

♡ ♀ ⊲  ⊓

251 likes

vuillard I'm sick of wallpapers

1 comment

 gauguin                    6h

♡ ⬭ ⬈                              ০ ০ ০

♥ 1806 likes
gauguin  About last night
view all 46 comments
Jesh 717 Sexy girls
adelhisa can I join ?
carter 239 I want to buy your art

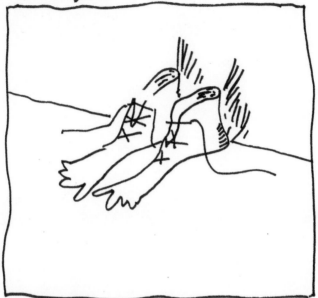

208 likes

magritte Footwear new collab
#sneakers #commissionart
runnerman 👟👟👟
shoelocker love
jordan28171 where can I buy?
bunnygirl want!

 breton_andre

...

♥ 170S likes
breton_andre have been writing
8 hrs straight today!
@marchepaulbert fantastic! 🐟🐟🐟
@lapetite parisienne you're so good♥♥
♥♥♥

🌐 andy_warhol                    ...

♡ ◯ ◁                                    ⊓

liked by viva, bob_colacello and
263 others
andy_warhol so excited by my
Mark Zuckerberg new series.
Billy said Facebook will buy it

🌐 a_giacometti                                    . . .

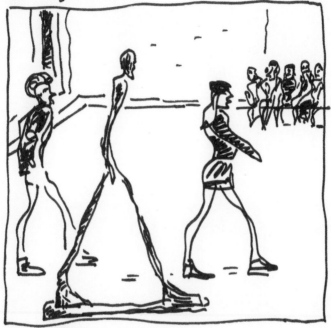

♡ ◯ ◁                                                🔖

liked by j.genet and 16 others
a_giacometti Finally, I participated
in a fashion show

minotauremag

· · ·

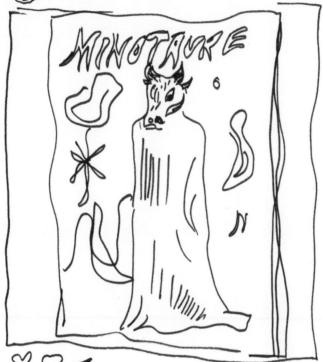

♡ ♡ ⤳

Liked by derain, dali, max_ernst and
504 others
minotauremag our fall/winter issue
is out! #fashion #art #surrealist
Diegorivera can you ship it to Mexico?

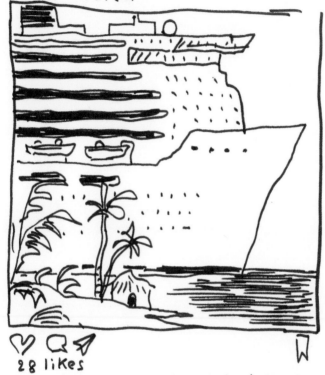

28 likes

top_cruises sail to the island
of Gauguin in luxury with ... more

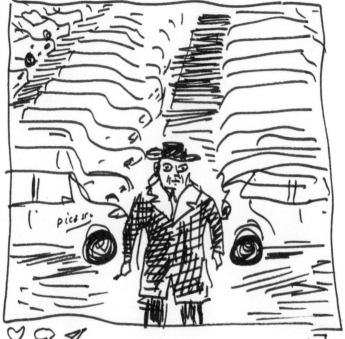

picasso

6700 likes
picasso signed 3M cars today!
collectors 🖤 🖤 🖤
automag 🖤
Louisedv you're amazing
view all 150 comments
2 hours ago

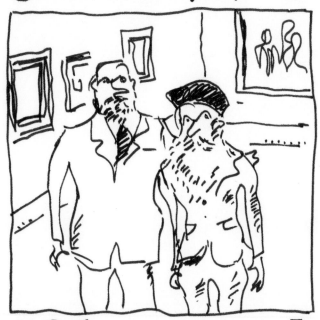

ambroise_vollard_gallery ...

liked by cezanne_paul, bonnard
and 150 others
ambroise_vollard_gallery surprise
visit by the great @renoir
on our booth today!
maillol it's not @renoir it's
me!

 h.matisse

...

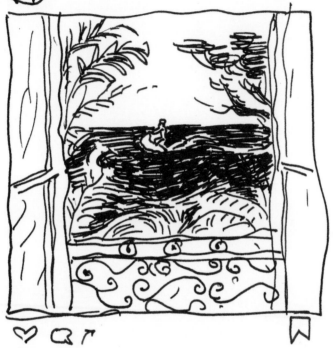

♡ ♡ ⤳

37 likes

h.matisse I can't bear the jetskis

3 hrs ago

@van-gogh

...

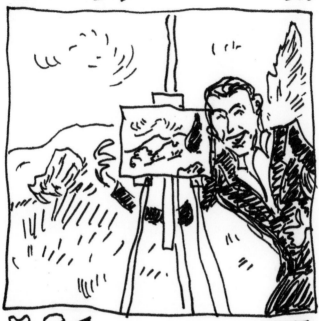

♡ ♡ ◻

12 likes

van-gogh A man in a suit who said
he's an artist stopped by and said
he has an idea to make lots of
products with my paintings.
gauguin He contacted me too. He wants
to do hand bags but I'd rather do
beach towels with my art.
manet #metoo

picasso                    3mn

♡ 🗨 ⌂ ↱              ...

picasso: my illustration for
Don Quixote #donquixote #cool
#art
gstein Amazing!
Sabartes ♥ 🖤 ♥

jack.pollock

$1500 FINE FOR URINATING HERE

♡ Q ◁

58 likes

jack_pollock you all go to hell shit painters

willemdek you drunk

cedartavern Keep sound level low for our neighbors

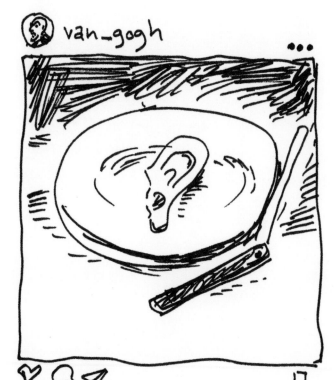

van_gogh

16 likes
van_gogh Fresh ear
cafedelagare Try it with sauce
ravigotte!

 **magritte**
Belgium

. . .

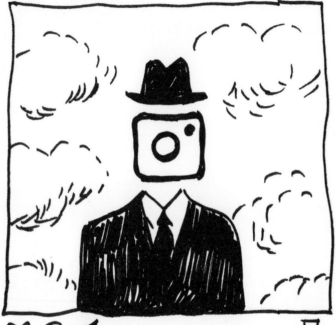

16 likes

magritte the mirror of man
#art #surrealism #belgium

First published in the United States of America
in 2019 by August Editions

www.august-editions.com

ISBN: 978-1-947359-04-8

First Edition

Printed in China